D0945226

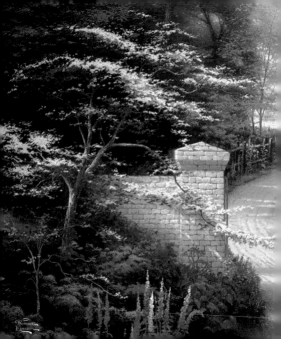

THOMAS KINKADE

Places in the Heart

**Andrews McMeel
Publishing**

Kansas City

For information, write Andrews McMeel Publishing, an Andrews McMeel Universal company, 4520 Main Street, Kansas City, Missouri 64111.

ISBN: 0-7407-2741-9
Library of Congress Control Number: 2002102581

Compiled by Patrick Regan

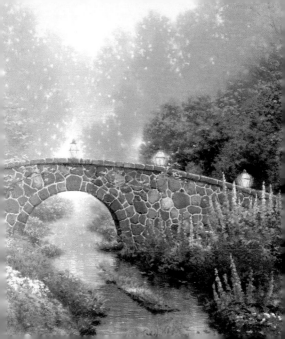

Extraordinary people are like extraordinary works of art. Their value and importance in your life lie not on the surface, but on a much deeper level. Indeed, what makes a person special is the same as what makes a painting or other work of art special—the real value is in how it makes you feel inside.

As a painter, I depict places and scenes that represent much more than what is immediately visible to the eye. I know that I have succeeded as an artist only when I have

captured the invisible and emotional aspects of a scene: the warmth, the light, the heart, the history, and the love.

My paintings capture places that don't appear on any map—they are places in the heart. And this book of images and words is dedicated to those people in our lives who occupy special places in our hearts. These are the people who truly bring light to our lives.

Thomas Kinkade

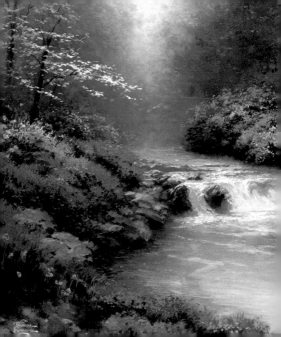

*L*ove is a canvas

furnished

by nature

and embroidered

by imagination.

—*Voltaire*

Wherever you are,

it is your friends

who make your world.

—*William James*

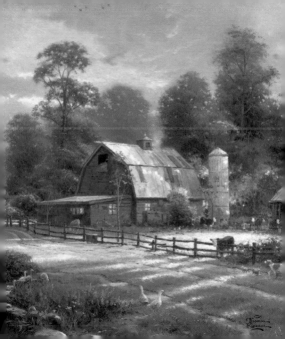

\mathcal{W}e are,

each of us,

angels

with only

one wing;

and we can

only fly

by embracing

one another.

—*Luciano de Crescenzo*

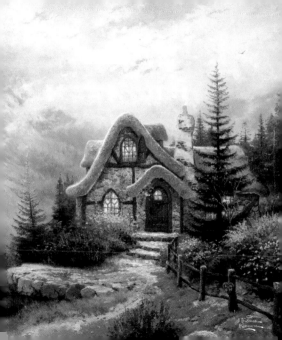

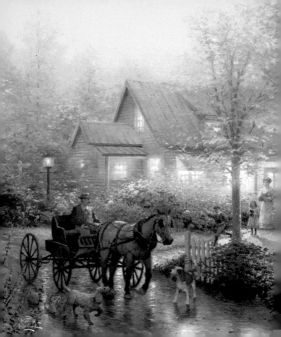

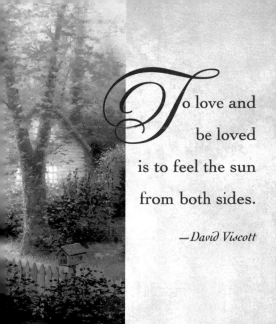

*T*o love and
be loved
is to feel the sun
from both sides.

—*David Viscott*

\mathcal{B}lessed
is the
influence
of one true,
loving
human soul
on another.

—*George Eliot*

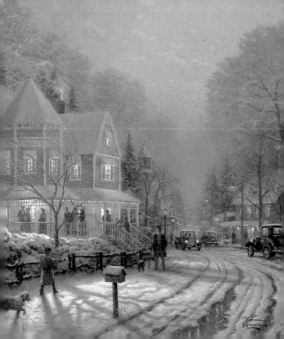

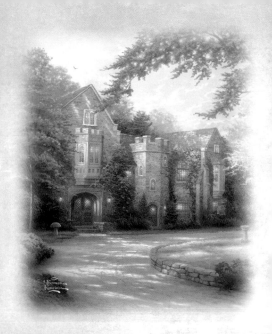

Cherish the people who make up your home, and you'll notice the hearth fires burn brighter than ever before.

—*Thomas Kinkade*

*B*ut here we are;
and, if we tarry a little, we may
come to learn that here is best.
See to it, only, that thyself is
here;—and art and nature,
hope and fate, friends, angels,
and the Supreme Being, shall not
be absent from the chamber
where thou sittest.

—*Ralph Waldo Emerson*

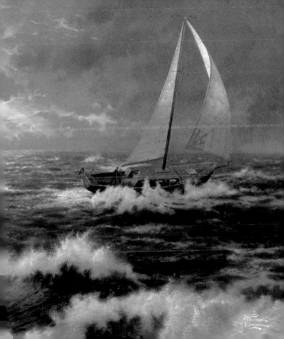

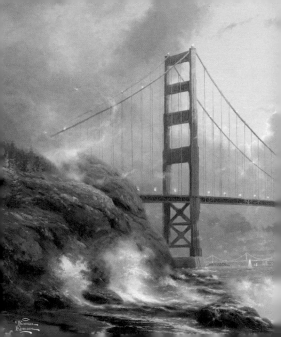

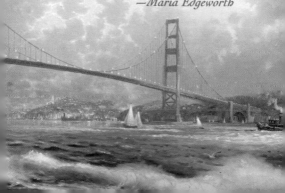

The human heart
opens only to the heart
that opens in return.

—*Maria Edgeworth*

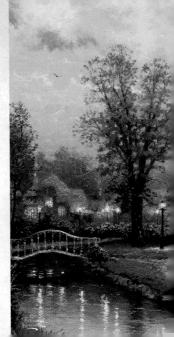

*L*ove
brings
bewitching
grace
into the
heart.

—*Euripides*

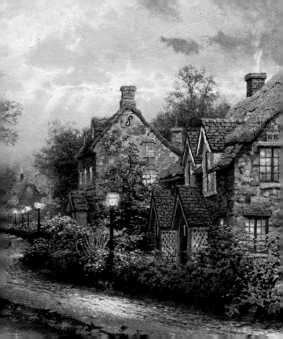

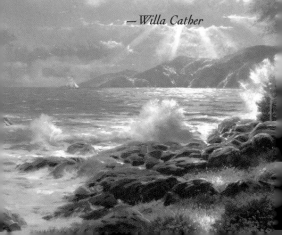

\mathcal{W}here there is great love,
there are always miracles.

— *Willa Cather*

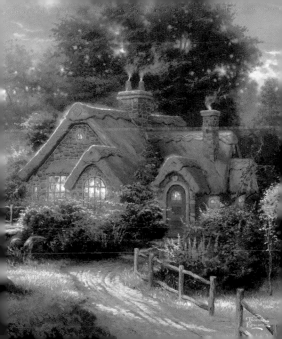

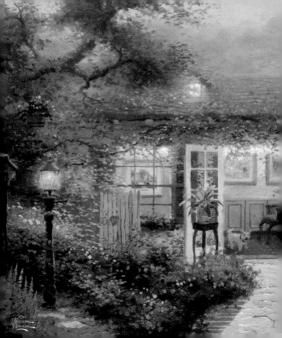

*L*et us be
grateful to people
who make us happy;
they are the charming
gardeners who make
our souls blossom.

—*Marcel Proust*

*E*very conversation, every

cuddle, every kiss and caress,

even every disagreement, adds

another brushstroke to the

picture of home you paint with

the days and hours of your life.

—Thomas Kinkade

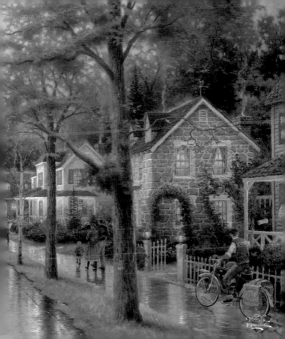

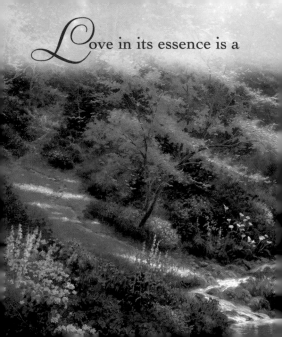

Love in its essence is a

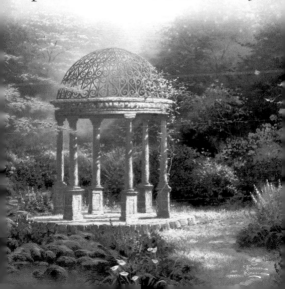

spiritual fire. —*Emanuel Swedenborg*

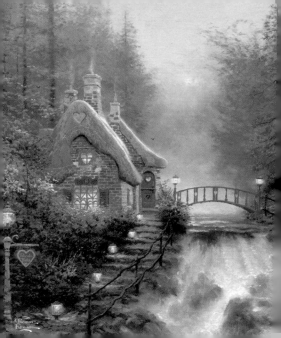

*L*ove is a force more

formidable than any other.

It is invisible — it cannot be

seen or measured, yet it is

powerful enough to transform

you in a moment, and offer you

more joy than any material

possession could.

transforms

—*Barbara De Angelis*

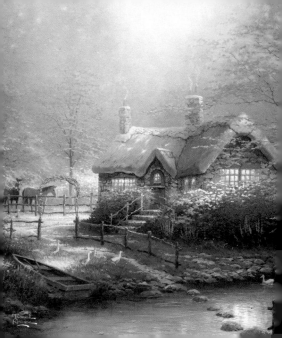

There is no
remedy
for love
but to
love more.

—Henry David Thoreau

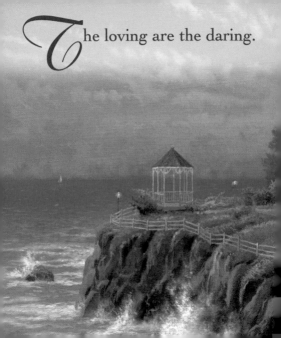

The loving are the daring.

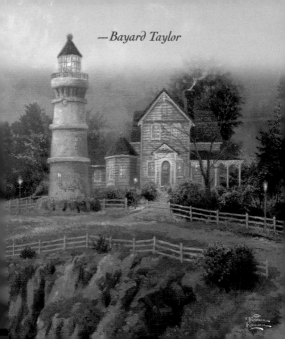

—*Bayard Taylor*

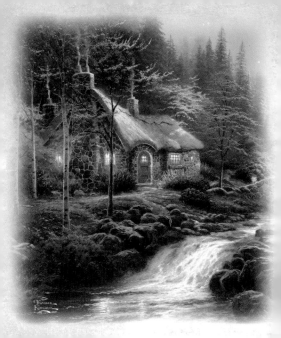

romantic

We all have
a romantic nature
of one kind or another
buried somewhere
in our hearts.

— *Thomas Kinkade*

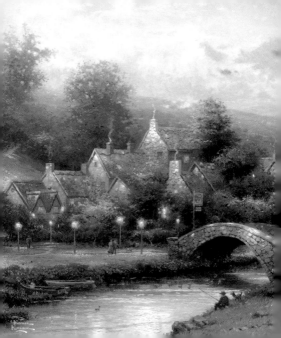

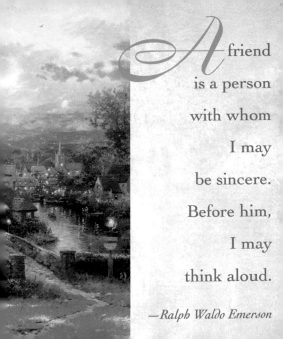

A friend
is a person
with whom
I may
be sincere.
Before him,
I may
think aloud.

—*Ralph Waldo Emerson*

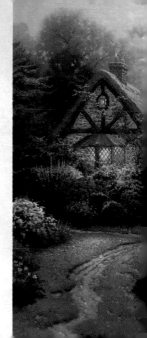

The love
we give away
is the only love

we keep.

—*Elbert Hubbard*

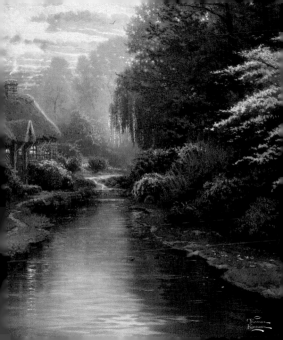

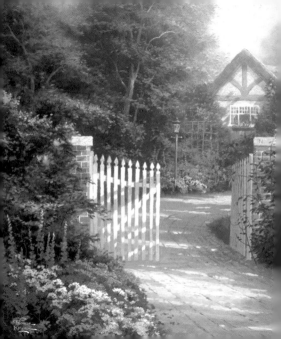

*L*ove
is something
eternal;
the aspect
may change,
but not
the essence.

—*Vincent van Gogh*

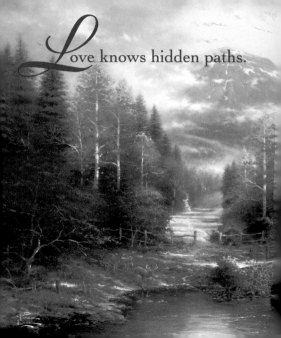

*L*ove knows hidden paths.

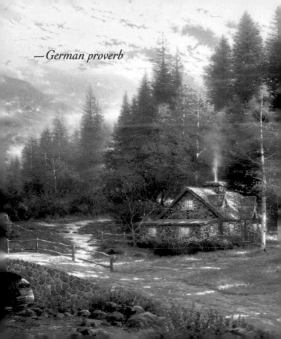

—German proverb

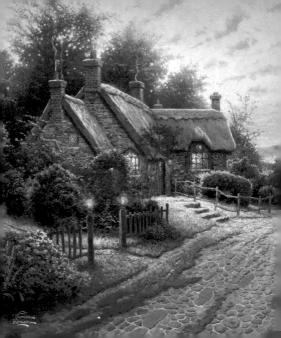

\mathcal{B}eauty is
found in
anything
that delights
the senses,
nourishes
the soul,
fires the
imagination.

—Thomas Kinkade

Whoever loves
true life
will love
true love.

—*Elizabeth Barrett Browning*

true love

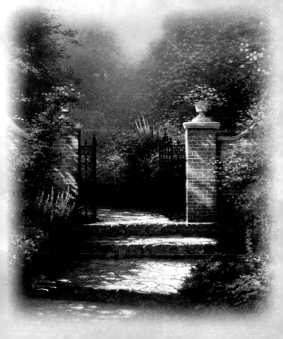

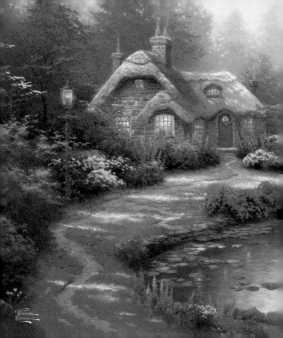

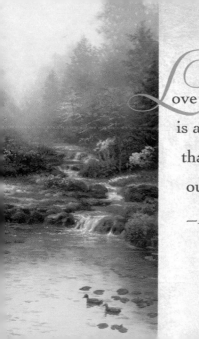

*L*ove
is a fire
that feeds
our life.

—*Pablo Neruda*

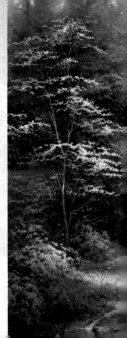

The workings
of the human
heart are the
profoundest
mystery of the
universe.

—*Charles W. Chestnutt*

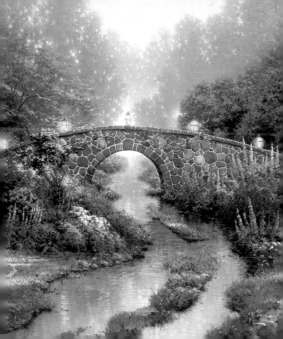

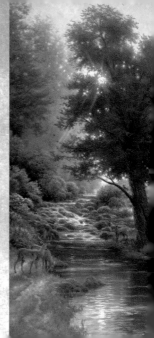

*L*ove
comforteth
like
sunshine
after rain.

—*William
Shakespeare*

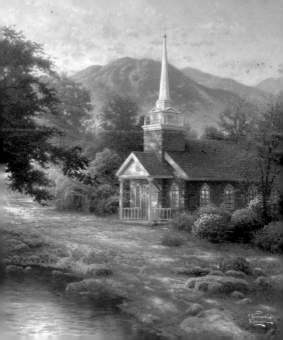

Our heart
has reasons
that reason
cannot know.

—*Blaise Pascal*

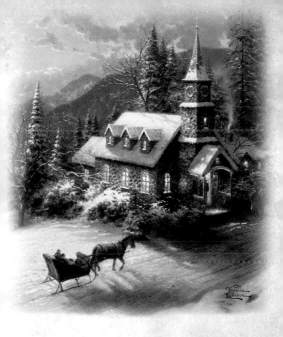

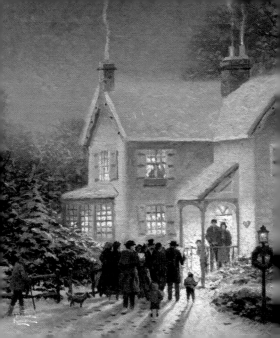

*L*ove is all we have,

the only way

that each

can help

the other.

—*Euripides*

The most wonderful of all things in life, I believe, is the discovery of another human being with whom one's relationship has a glowing depth, beauty, and joy as the years increase.

—*Sir Hugh Walpole*

beauty

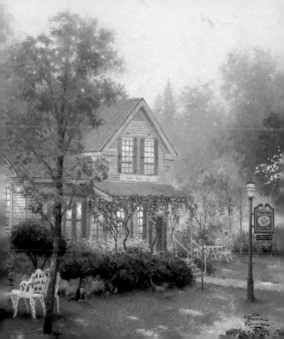

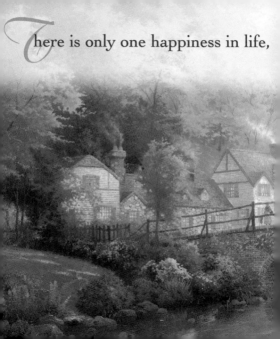

There is only one happiness in life,

to love and be loved. —*George Sand*

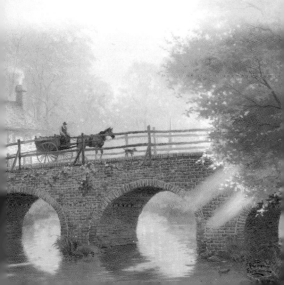

*S*urround
*y*ourself
 with the kinds
 of input
that are uplifting,
 that expand
 your mind
and settle
 your spirit.

— *Thomas Kinkade*

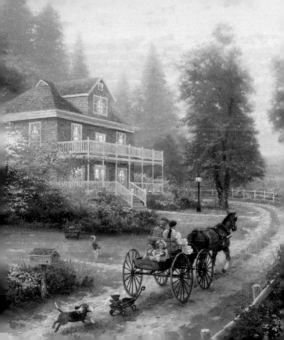

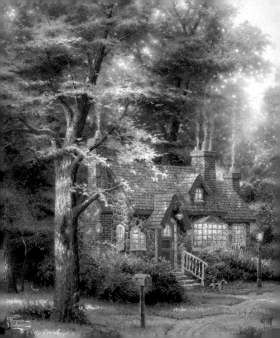

We are all born
for love.
It is the principle
of existence,
and its only end.

—*Benjamin Disraeli*

*L*ove is the poetry
of the senses.

—*Honoré de Balzac*

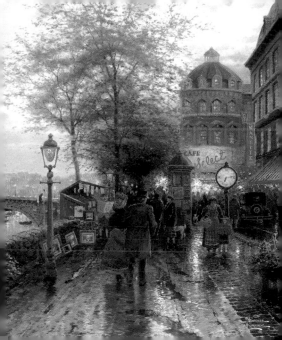

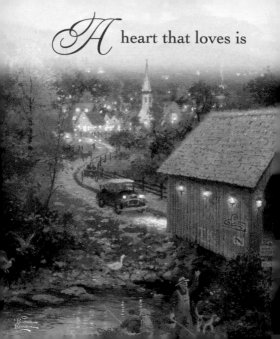

H heart that loves is

always young. —*Greek proverb*

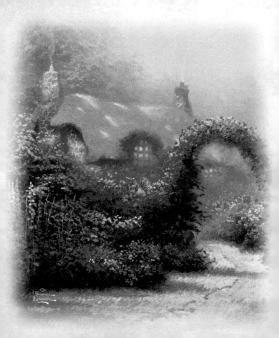

To cheat one's self out of love is the greatest deception of which there is no reparation in either time or eternity.

—Søren Kierkegaard

eternity

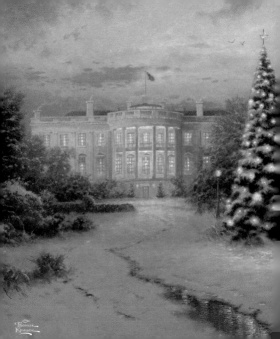

*L*ook forward, imagine what your thoughts and feelings might be as you approach the end of your days. What will be important to you then?

—Thomas Kinkade